Barrel
of
Monkeys

A Compendium of
Collective Nouns for Animals

Compiled by
Samuel Fanous

With illustrations by
Thomas Bewick

Bodleian Library
UNIVERSITY OF OXFORD

Foreword

THE TERM 'collective noun' seems an unfairly dry choice for what is surely one of the richest areas of our language, one that has entertained us for centuries. Whether it's the medieval 'leap of leopards' or today's tongue-in-cheek 'clutch of car mechanics', users of English hold such group names in special affection. Occasionally they might even have a go at creating their own. One of the most frequent questions put to any lexicographer is 'Who decides? Who judges when a new term becomes "official"?' The simple answer, every time, is 'We all do'. English has no law-makers or academy presiding over its evolution, or righting perceived abuses. Instead it moves as it pleases, allowing us to take it where we will

because, as with any true democracy, it will change when enough of us want it to. Put that freedom alongside English-speakers' particular love of wordplay, and you have an exciting combination: the collective noun is a near-perfect showcase for English speakers' exuberance and inventiveness.

The majority of our most established collective nouns sprang from the medieval imagination; their survival and popularity were ensured by the growing successes of printers like the aptly-named Wynkyn de Worde. Lists of such evocative coinages as 'a busyness of ferrets' or 'a melody of harpers' were a frequent component of works that sought to educate the nobility in gentlemanly pursuits. One of the most influential of such offerings was the fifteenth-century *Book of St Albans*, a three-part compendium on the important matters of falconry, heraldry and hunting. In the *Book*'s third volume are what are believed to be the first colour-printed images in Tudor England, but just as valuable are the most complete and novel lists of collective

nouns that the period produced. Their authorship is attributed to Dame Juliana Berners, Prioress of the Sopwell nunnery near St Alban's, who gathered the best examples from older French texts. The result is a sumptuous array of collective terms for animals, birds and personalities that still resonates with the modern mind. Once heard, it is hard to forget such creations as 'a trip of stoats' and 'a cackle of hyenas'.

Many such names reflect the allegorical teachings of bestiaries: popular and luxuriously illustrated moral treatises that drew on animal behaviour for instruction. In the assortment that follows you will find 'a cowardice of curs', 'an obstinacy of buffaloes', a 'skulk of foxes', and the intriguing 'implausibility of gnus'. Elsewhere, medieval choices reflect the value a particular animal held in contemporary society: 'a richness of martens', for example, may be explained by the fact that the pelt of such animals was

highly prized in Tudor society as a visual indicator of rank and birth.

From the very beginning, humour has been a close cousin of the collective noun. We can all appreciate the reasoning behind a 'surfeit of skunks', 'a piddle of puppies' and 'a mischief of mice'. For their appeal to the mind's eyes and ears, meanwhile, it would be hard to better 'a crash of rhinos', 'a bloat of hippopotamuses' or a 'dazzle of zebras'. Coinages like these need almost no illustration, for the mind will readily supply the image. I say *almost* no illustration: the engravings of Thomas Bewick, with their keenly-observed vignettes of natural life, are worthy companions to this collection. Their lively and sympathetic images deliver as much of a story as the terms they illustrate.

Happily, it seems we may never tire of asking 'What's the collective noun for...?' *A Barrel of Monkeys* will supply many of the answers, while allowing us an engrossing stroll through the medieval imagination along the way.

Compiler's Note

Thomas Bewick's superb wood engravings give this book its overall shape. Many other animals have been grouped by collective nouns, though only those engraved by Bewick are included here. While some animals have received more than one collective noun, not all carry the same weight. Some nouns have stood the test of time where others have fallen out of use. Even so, numerous competing collective nouns for the same animal are still current today. In compiling this selection, I have relied on several key texts below, informed by contemporary usage. The possibilities are numerous. All lists are subjective and inevitably represent the individual choices of the compiler.

SOURCES CONSULTED

Juliana Berners, *The Boke of Saint Albans by Dame Juliana Berners, 1486, Reproduced in Facsimile* (London, 1881).

Sue Ellery, *Gallimaufry: A Quiddity of Collective Nouns and Other Profundities* (2012).

C.E. Hare, *The Language of Sport* (London, 1939).

James Lipton, *An Exultation of Larks*, 4th edn. (New York, 1993).

Ivan G. Sparks, *Dictionary of Collective Nouns and Group Terms* (London, 1985).

Joseph Strutt, *Sport and Pastimes of England* (London, 1810).

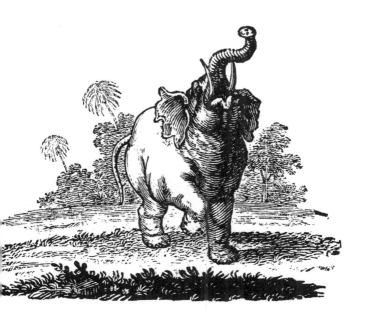

A *tribe* of antelopes

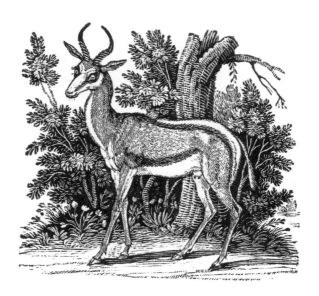

A
shrewdness
of
apes

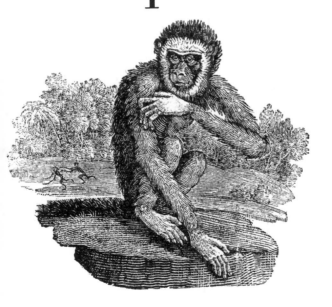

A *pace* of asses

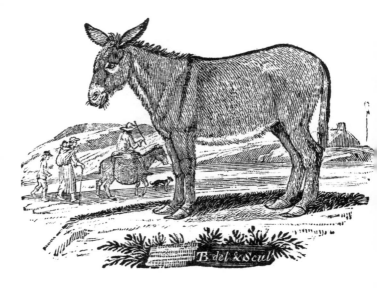

B del & Scul

A *flange* of baboons

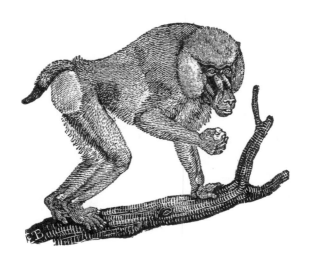

A
cete
of
badgers

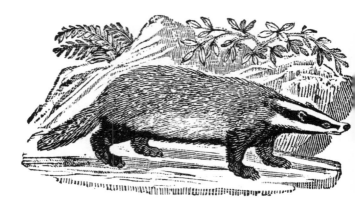

A *colony* of bats

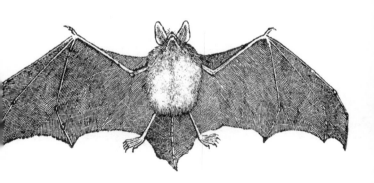

A *sloth* of bears

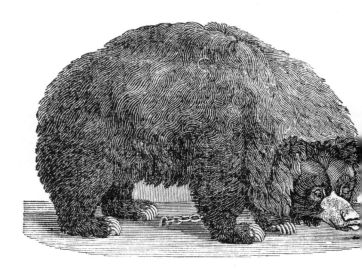

A *family* of beavers

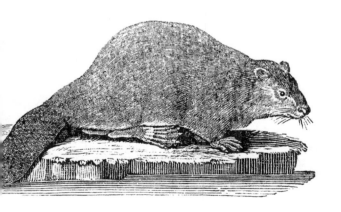

A *herd* of bison

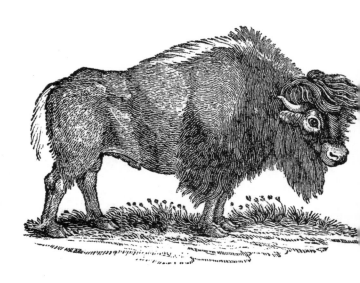

A
sute
of
bloodhounds

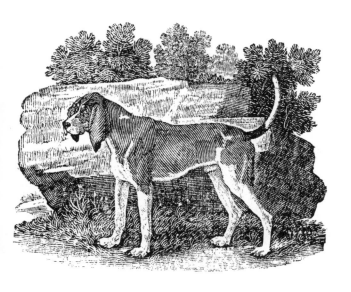

A *singular* of boars

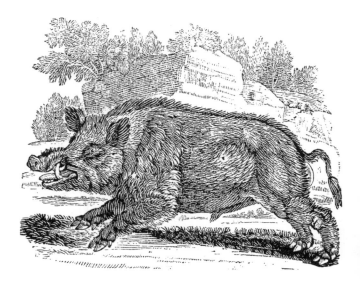

An *obstinacy* of buffaloes

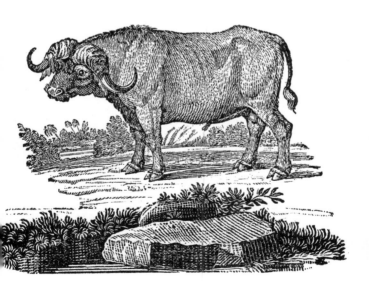

A
caravan
of
camels

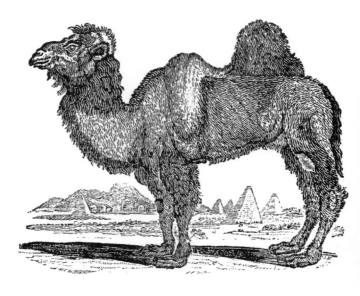

A *herd* of capybara

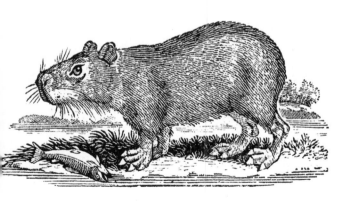

A *pair* of caracals

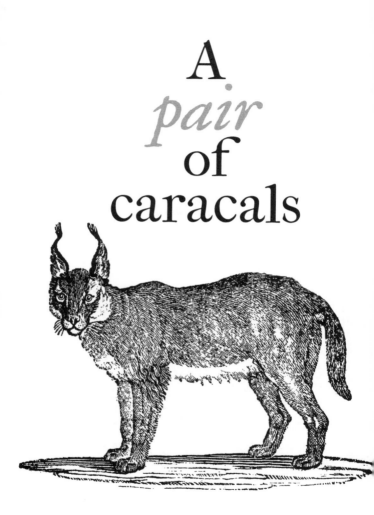

A
clowder
of
cats

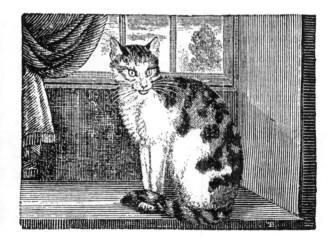

A *drove* of cattle

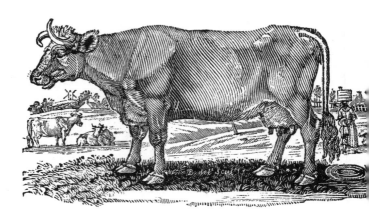

A *herd* of chamois

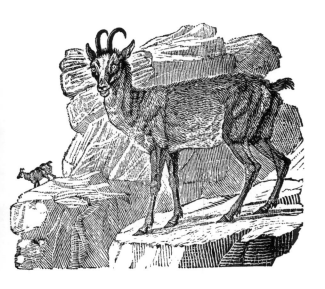

A
pair
of
civets

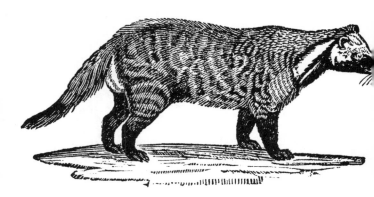

A *nursery* of coati

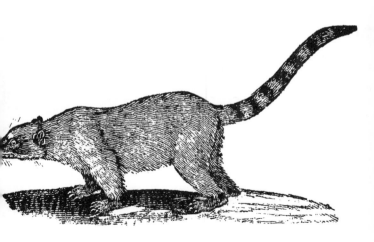

A *lap* of cod

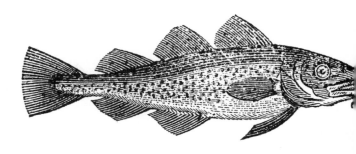

A *rag* of colts

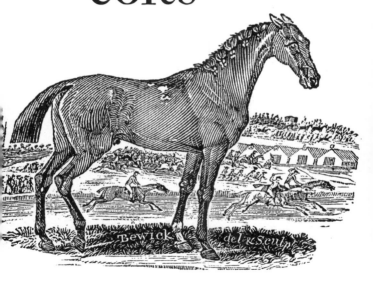

Bewick del et Sculp

A *bury*
of
conies

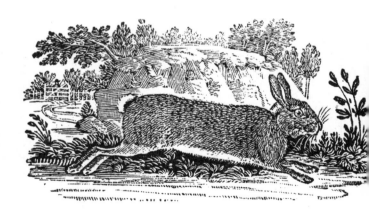

A *kine* of cows

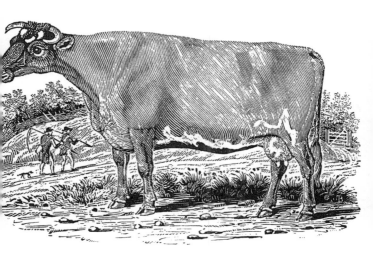

A *litter* of cubs

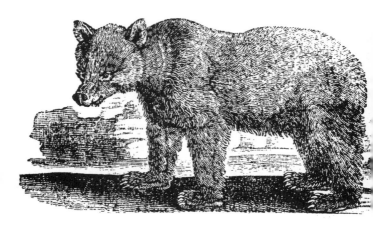

A
cowardice
of
curs

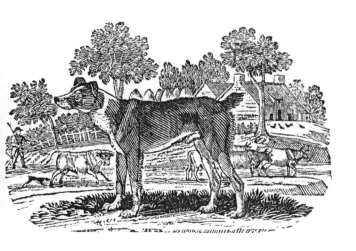

A *herd* of deer

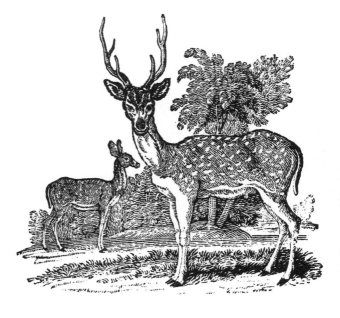

A
kennel
of
dogs

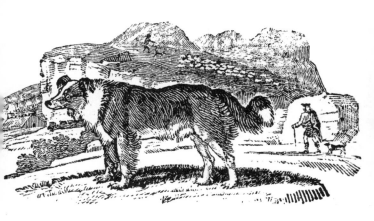

A
school
of
dolphins

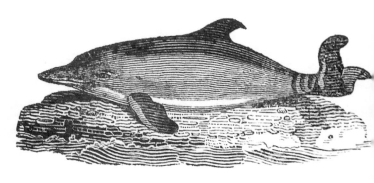

A
nest
of
dormice

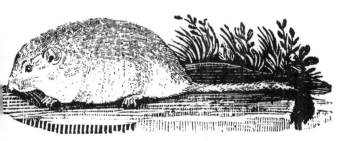

A *train* of dromedaries

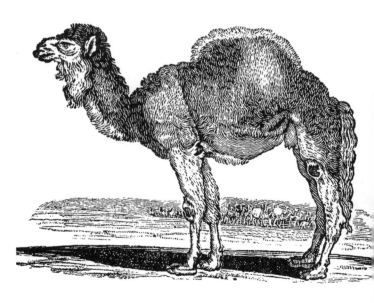

A *herd* of elephants

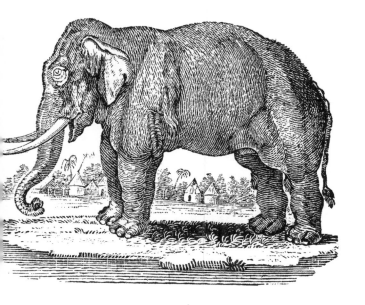

A
gang
of
elk

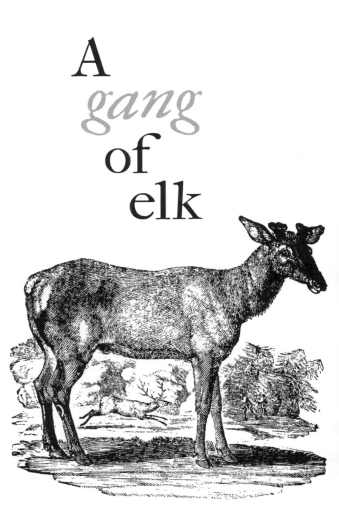

A *parcel* of ewes

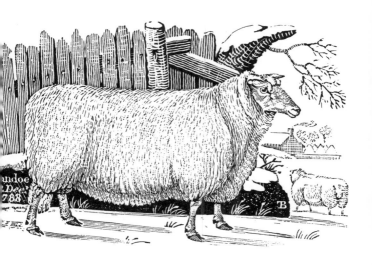

A
busyness
of
ferrets

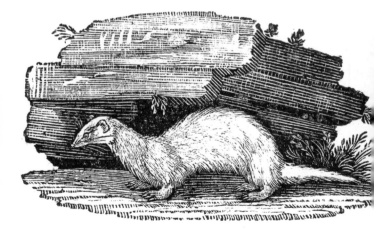

A
kettle
of
fish

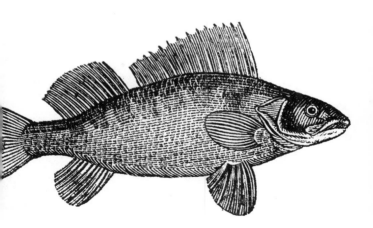

A
skulk
of
foxes

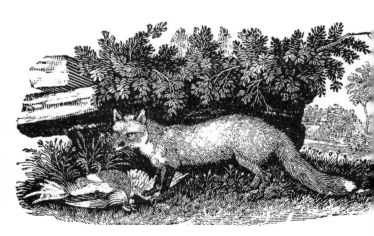

A
pair
of
genets

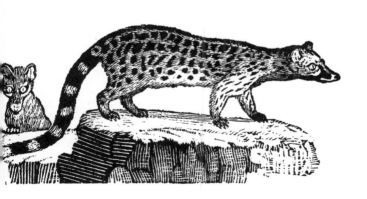

A *tower* of giraffes

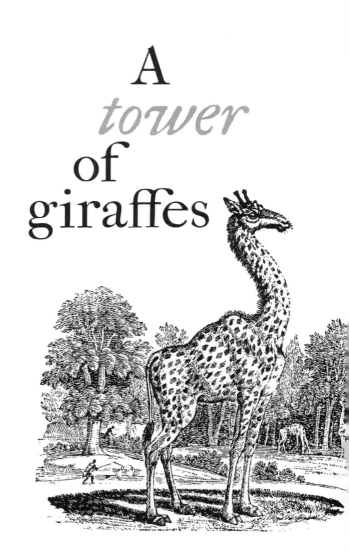

A
trip
of
goats

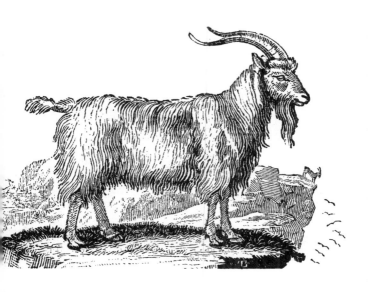

An *implausibility* of gnus

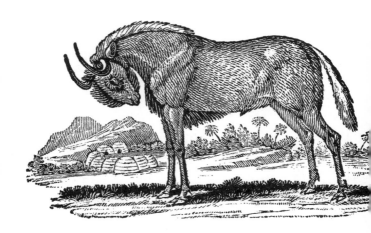

A *leash* of greyhounds

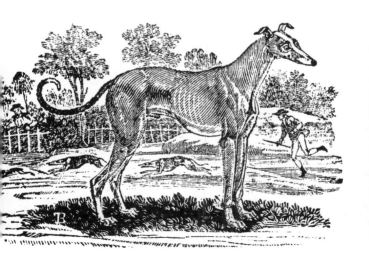

A *group* of guinea pigs

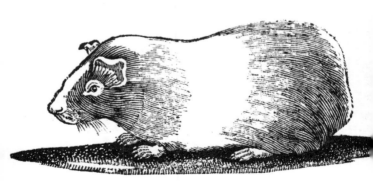

A *horde* of hamsters

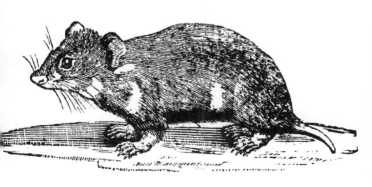

A *husk* of hares

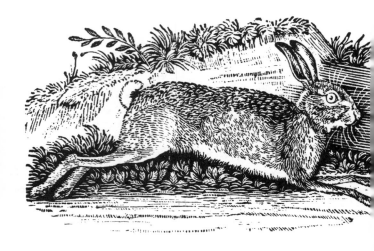

A *herd* of harts

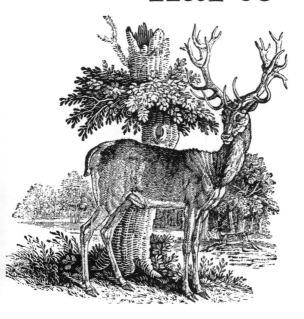

A *herd* of hartebeests

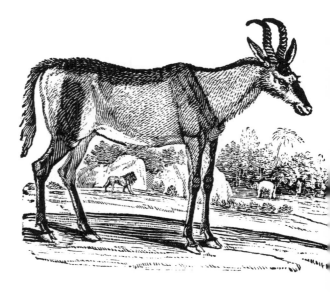

A
nest
of
hedgehogs

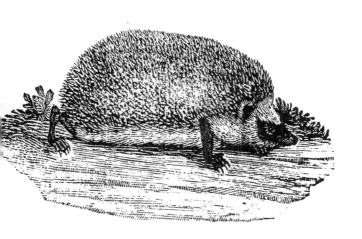

An *army* of herring

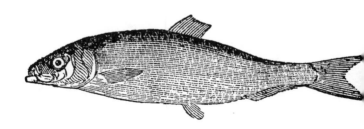

A *bloat* of Hippopotamuses

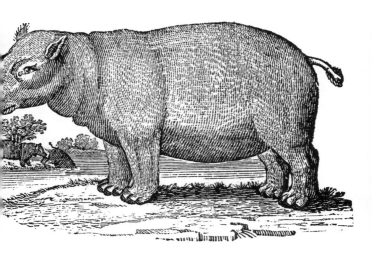

A
drift
of
hogs

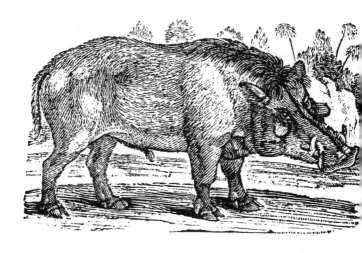

A
clan
of
honey
badgers

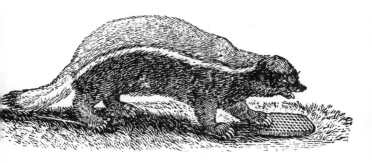

A *harras* of
horses

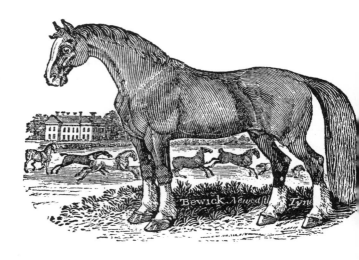

A
cry
of
hounds

A *team* of huskies

A
cackle
of
hyenas

A
herd
of
ibex

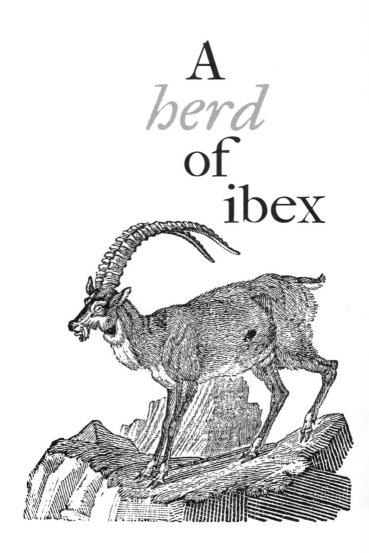

A
skulk
of
jackals

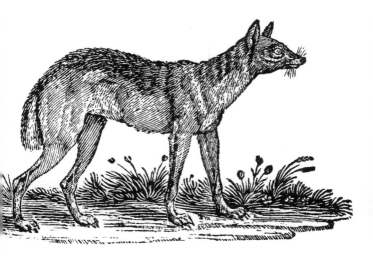

A *mob* of kangaroos

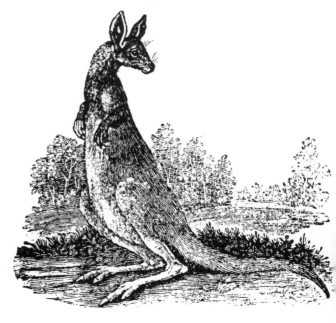

A *troop* of lemurs

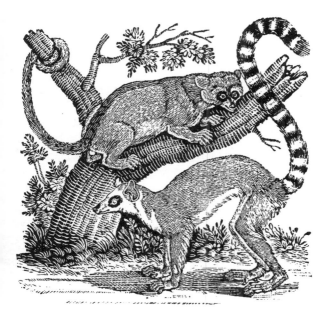

A
leap
of
leopards

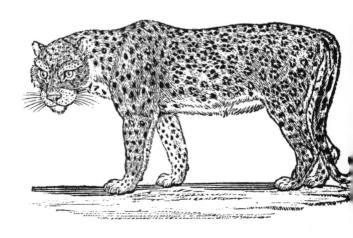

A *pride* of lions

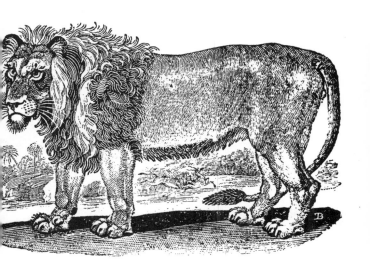

A *chain* of lynxes

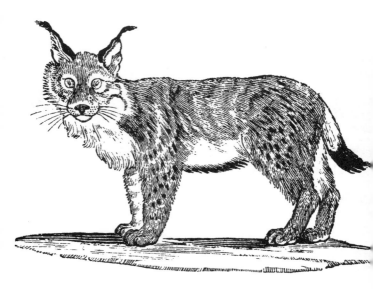

A *shoal* of mackerel

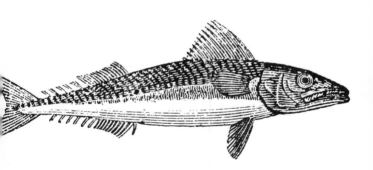

A *stud* of mares

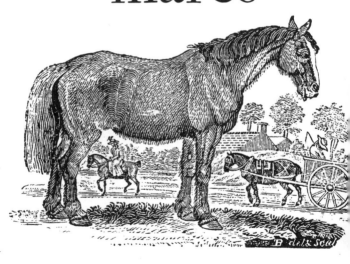

A
madness
of
marmots

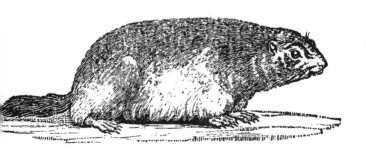

A
richness
of
martens

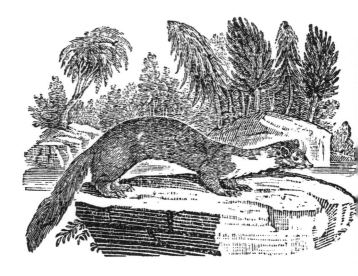

A *canopy* of margays

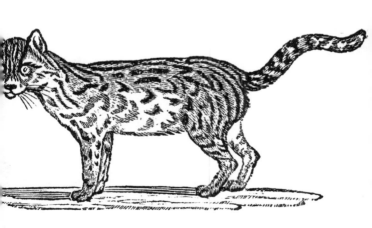

A *mischief* of mice

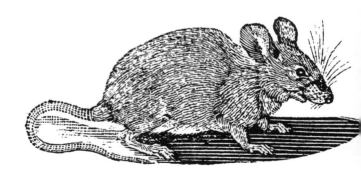

A *labour* of moles

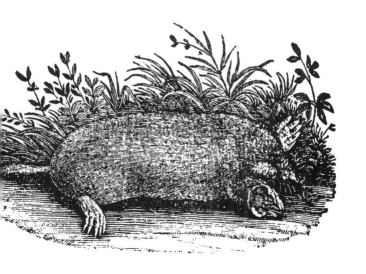

A
band
of
mongooses

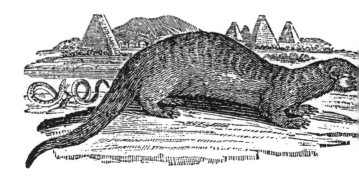

A *barrel* of monkeys

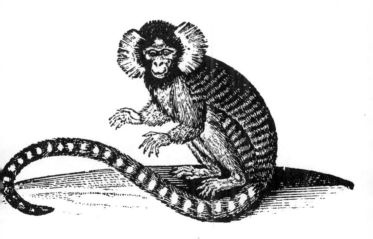

A *barren* of mules

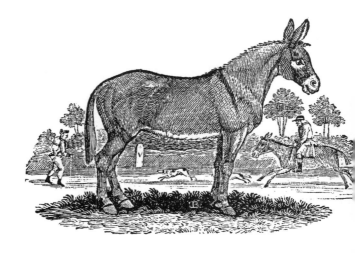

A
blessing
of
narwhals

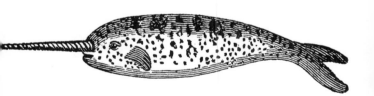

A *urination* of ocelots

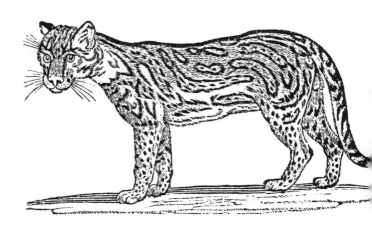

A *bevy*
of
otters

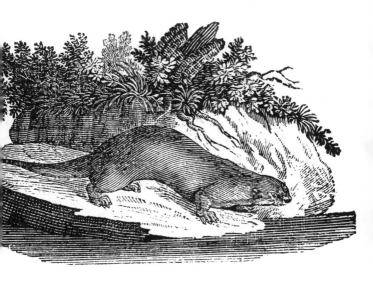

A *yoke* of oxen

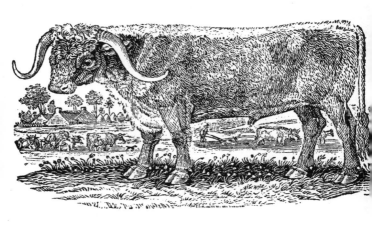

A *drove* of pigs

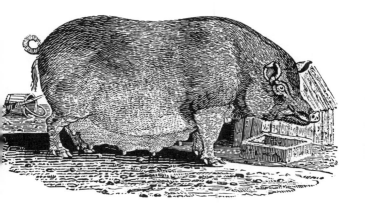

An *aurora* of polar bears

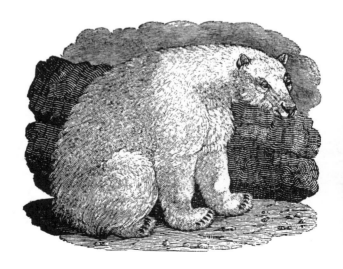

A
chine
of
polecats

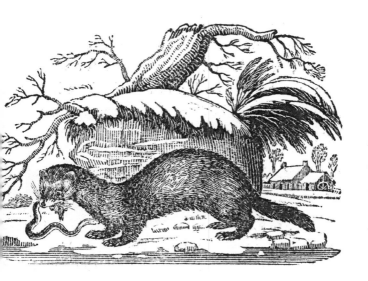

A
prickle
of
porcupines

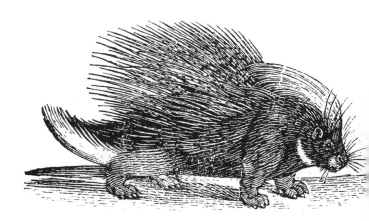

A
passel
of
possums

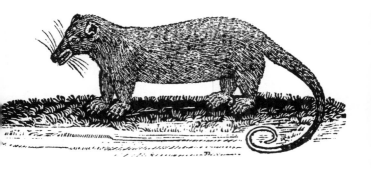

A *piddle* of puppies

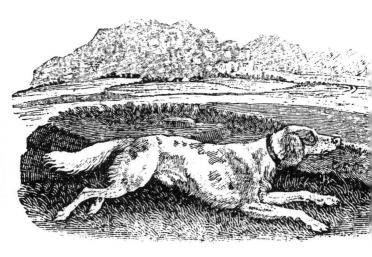

A *warren* of rabbits

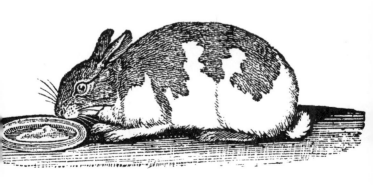

A
mask
of
raccoons

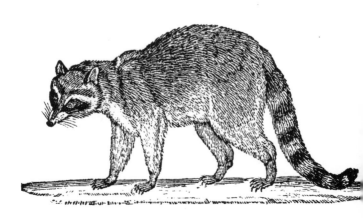

A *string* of racehorses

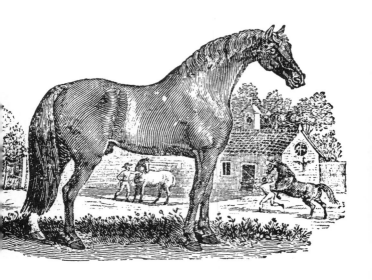

A *mob* of rams

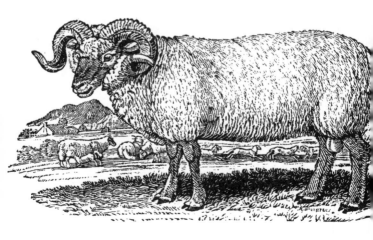

A
pack
of
rats

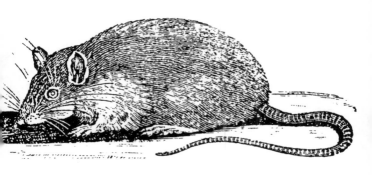

A
fever
of
rays

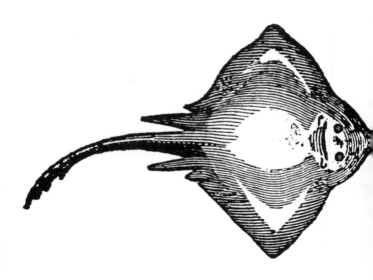

A *colony* of
of
red squirrels

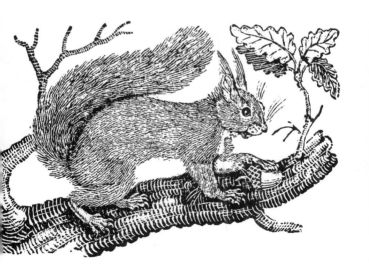

A *herd* of reindeer

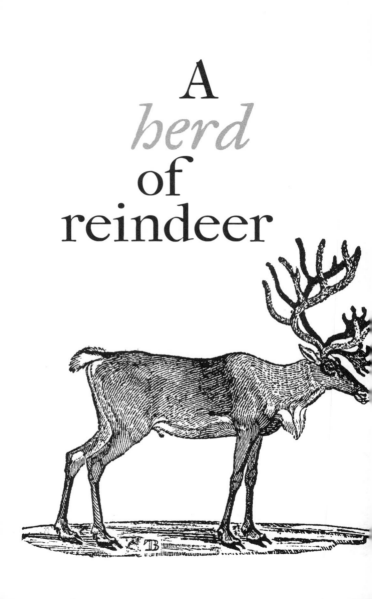

A *crash* of rhinoceroses

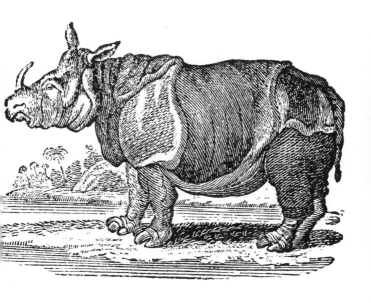

A
bevy
of
roebucks

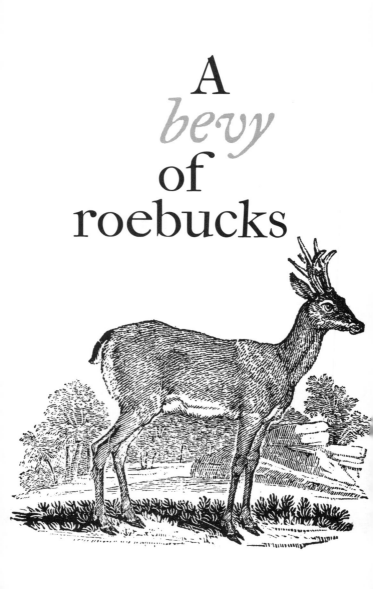

A
sneak
of
sables

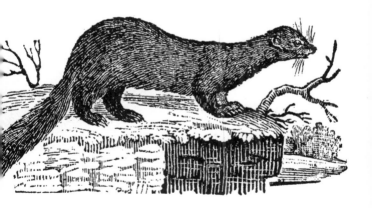

A
run
of
salmon

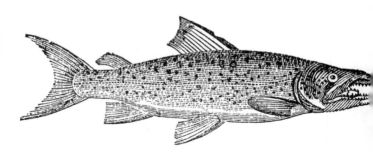

A *herd* of seahorses

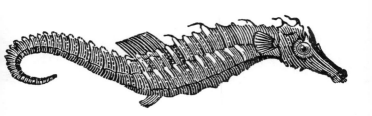

A
raft
of
sea otters

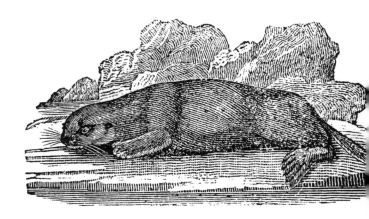

A
pod
of
seals

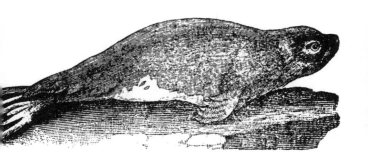

A
pair
of
servals

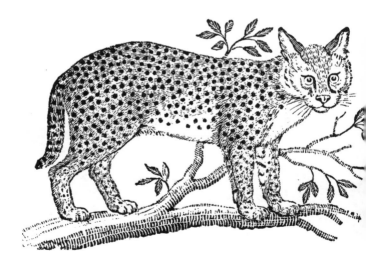

A
shoal
of
sharks

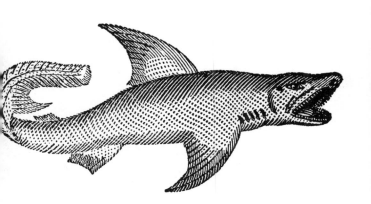

A *flock* of sheep

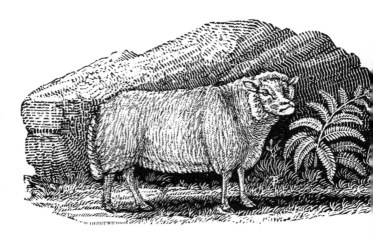

A
race
of
shrews

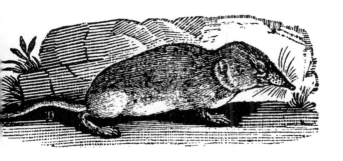

A *surfeit* of skunks

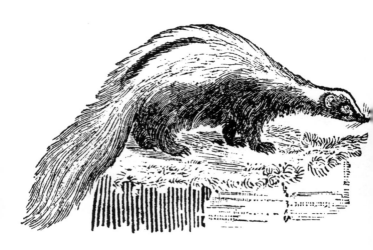

A *dray*
of
squirrels

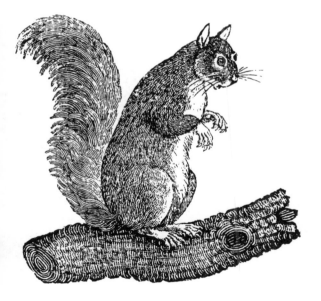

A
game
of
stags

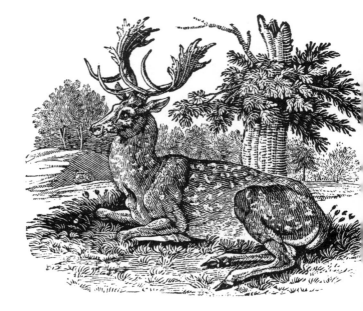

A *trip* of stoats

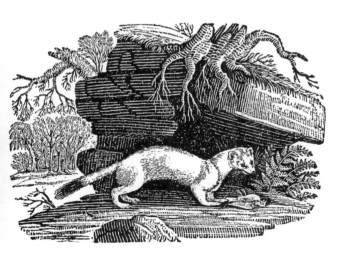

A *sounder* of swine

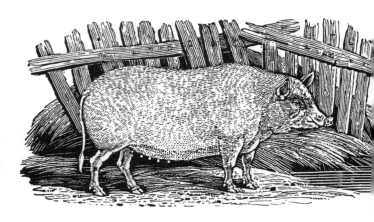

A
herd
of
tapirs

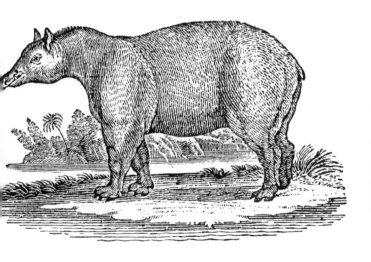

An
ambush
of
tigers

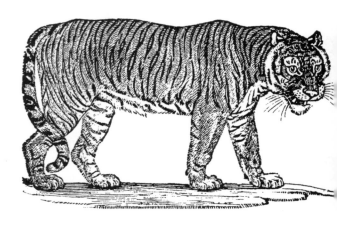

A
colony
of
voles

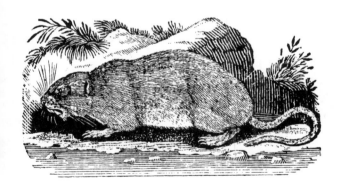

A
colony
of
weasels

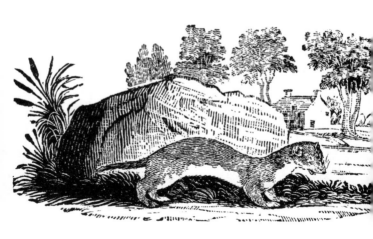

A *gam* of whales

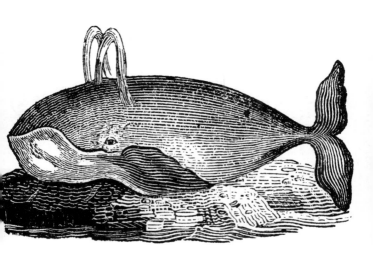

A *destruction* of wild cats

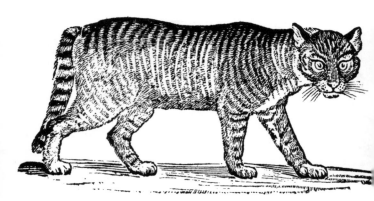

A *fall* of
woodchucks

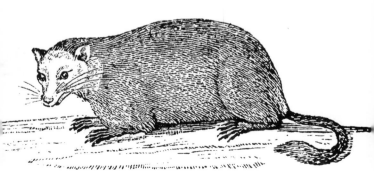

A *mob* of wolverines

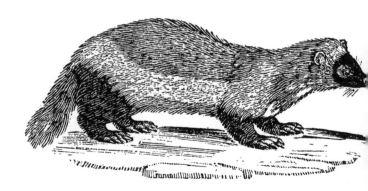

A
pack
of
wolves

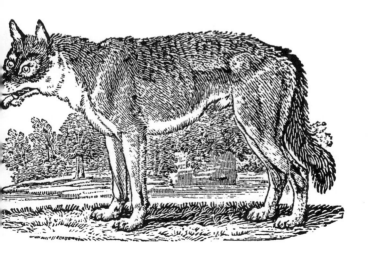

A
dazzle
of
zebras

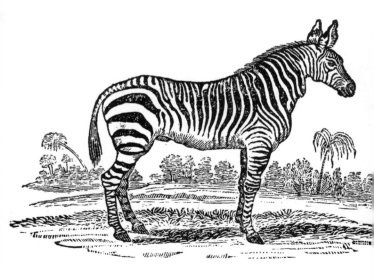